CELTIC DESIGN

Aidan Meehan studied Celtic art in Ireland and Scotland
and has spent the last two decades playing a leading role
in the renaissance of this authentic tradition. He has given
workshops, demonstrations and lectures in Europe and the
USA, and more recently throughout the Pacific North West
from his home base in Vancouver, B.C., Canada.

CELTIC DESIGN

SPIRAL
PATTERNS

AIDAN MEEHAN

With over 400 illustrations

THAMES AND
HUDSON

artwork and calligraphy
copyright © 1993 Aidan Meehan

First published in the United States of America in 1993 by
Thames and Hudson Inc., 500 Fifth Avenue,
New York, New York 10110
Reprinted 1999

Library of Congress Catalog Card Number 92-62132

ISBN 0-500-27705-2

Printed and bound in Spain

CONTENTS

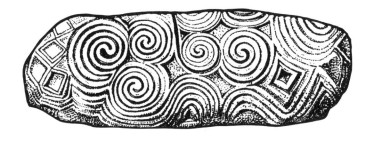

Kerbstone K1, at entrance to Newgrange.

INTRODUCTION

ELTIC, SLAVIC, GREEK, Latin, Scandinavian, Armenian, Semitic and Indian languages all share common ancestry, but "the fallacy that identity of language or of culture necessarily implies identity of race must be carefully guarded against", as James Romilly Allen pointed out a century ago. Or, people who wear jeans and sneakers are not necessarily Americans.

Introduction

OLD EUROPE was a patchwork quilt of many cultures. Celts mixed with so many peoples that the "pseudo-myth of race" does not apply to their art. It is not ethnic. It is classical abstract art, as accessible as classical music for instance. It is a way of making visual music rather than of telling a story. We put words to the symbol, and interpret the pattern, but this is not necessary. To ask what does a spiral pattern mean is like asking what does music mean.

With practice these patterns can be articulated in a way that communicates information to other Celtic artists or to anybody who can read and follow its formal conventions.

[8]

THE SOURCES illustrated in this book record ancient thought processes, by means of which we can be touched directly by a multitude of voices across time itself. The reward of this "engrossing quest", as George Bain described his life study of Celtic art, is the reali- zation that this medium of art lets us travel through time to share the ideas of strangers from the deep past. It is as thrilling, say, as if we could hear a harp actually being played a thousand years ago. This book is a cargo of just such a voyage: a coracle filled with the haul of time, perennial notions encapsulated in stone, clay, bronze, iron, vellum, and, as here, on the printed page.

Introduction

I HOPE this book gives you ideas for making beautiful spiral patterns that engage your mind as much as your eye, as do the traditional designs presented here. Celtic spirals are abstract patterns that carry logical information, as we shall see. We did not know abstract art a century ago, when Romilly Allen first unveiled Celtic art to his fellow Antiquarians of Scotland. Since the Crafts Revival trampled the fence between fine and applied art, the acceptance of Celtic art is much wider today than in the mid-twentieth century, when George Bain took it off the dusty shelf of antiquarian research and showed it to school children.

CHAPTER 1

PRE-HISTORIC SPIRALS

SPIRALS HAVE CAUGHT the human mind since the Stone Age at least. They have symbolized life to so many civilizations down the ages that spiral patterns have become a pan-continental heritage. The pattern of *fig.1*, for example, is recorded by H. S. Crawford in his book, ***Irish Carved Ornament***, p. 17, as it appears roughly 6000 years later, on a slab in Clonfert.

FIG. 1 Vinca Vase, Running S-scroll, Yugoslavia, c. 5100 BC.

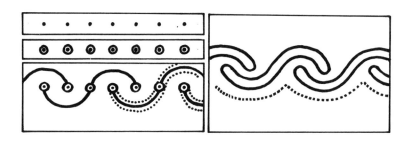

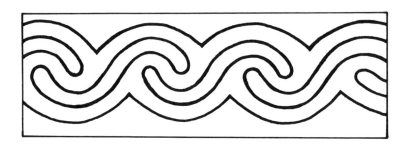

Large vases from Central Europe often have spirals like this, usually in a band around the waist.

FIG. 2 Statenice Dish, Border,
 Bohemia, c. 5000 BC.

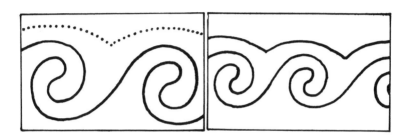

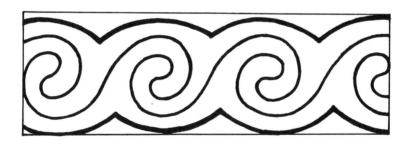

A variant of the same pattern, this
one a continuous line, comes from
this neolithic painted dish.

FIG. 3 Nebo Vase, Overall Spirals, Yugoslavia, c. 4800 BC.

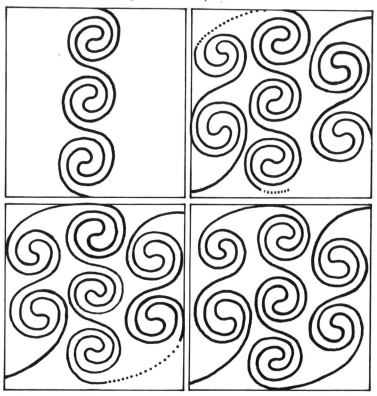

This hexagonal S-scroll border is connected top and bottom by C-scrolls.

FIG. 4 Nebo Vase, Spirals,
 Yugoslavia, c. 4800 BC.

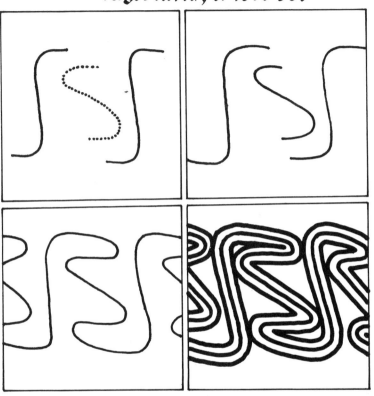

The split ribbon is two movements
of S~shapes, large vertical S's
connected by smaller diagonal ones.

FIG. 5 Butmir Mushroom Vase, Spirals, Sarajevo, c. 4500 BC.

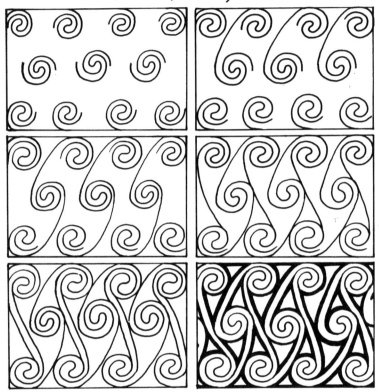

Interlocked C-scrolls alternate with S-scrolls to form a horizontal, marching rhythm.

Fig. 6 Tarxian, Spiral Interlock
 Border, Malta, c. 3000 BC.

Ram's-horn motifs inside breast
shapes read equally as fore- or as back-
ground in this design.

[17]

FIG. 7 Sipenitsi, vase, running S-
Scroll, W. Ukraine, c. 3800 BC.

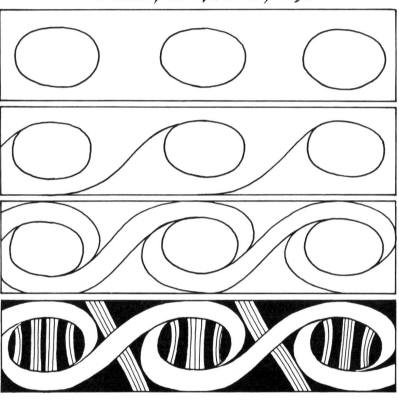

This vase border is a discontinuous
path. The spiral centre resembles the
Ukrainian decorated egg.

[18]

FIG. 8 Sipenitsi, Vase, Running S-
Scroll, W. Ukraine, c. 3800 BC.

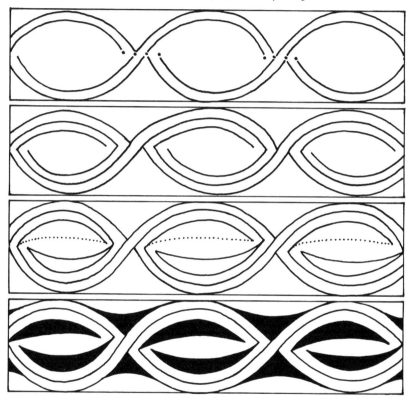

This vase border is a continuous
path. The flattened spiral lines
create a vulviform motif.

FIG. 9 Mycenæan Grave Stele,
Crete, c.1775 BC, Construction.

Note the connecting order : twos at
the corners, threes on the edge,
and fours inside.

FIG. 10 Mycenæan Grave Stele,
 Crete, c. 1775 BC.

FIG. 11 Mycenæan Spiral Border,
 Crete, c. 1125 BC.

From the royal tomb at Mycenae, a
pillar decorated with zigzags of
running S-scrolls. The apex shows
how to turn a corner.

CHAPTER II

MEGALITHIC SPIRALS FROM NEWGRANGE

PIRALS go back a long way, as we have seen in the last chapter. The earliest we have seen that anticipate the form of Celtic spirals are more than seven thousand years old. Spiral patterns were seemingly used by all the cultures of the Civilization of Old Europe, the name given by Marija Gimbutas to that high culture between the Stone Age and the Bronze Age.

[23]

FROM 5000 to 3000 BC, the domestication of animals and food plants was well under way. Arts and crafts flourished. It was the age of pottery, and with pottery came the art of painting spirals. On many painted pots beautiful patterns of running double spirals and S-scrolls recur. Towards the end of this period great stone (megalithic) tombs appear. The best known of these in Ireland is Newgrange which sits among over forty megalithic sites in an area of the Boyne Valley less than four miles square. In Irish legend it has always been the *Bruig na Boinne*, or "Hostelry of Boand", from *Bou-Vinda*, meaning Cow-White, the goddess name from which the rivername derives.

[24]

Megalithic Spirals from Newgrange

FIG. 12 Newgrange, Plan and Elevation.

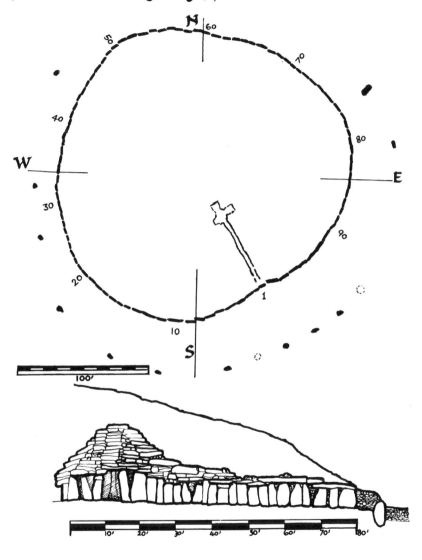

AT the entrance of the tomb is
a magnificently ornamented
kerbstone, with double spirals
arranged on either side of a vertical
dividing line. On the left are three
spirals in a triangular formation, in
which a triskele is centrally embedded.
On the right is a pair of spirals link-
ed in an S-form. It is fitting that
this entrance to the other world
should be decorated with a pattern
that describes in symbolic terms
the division between two opposites,
odd and even, triple and double.
Another richly patterned, vertically
divided kerbstone, number K 52,
lies on the far side of the mound
opposite the entrance. These two
mark a diameter dividing the
entire mound itself.

FIG. 13 Newgrange Decorated Kerbstones,
K1, K52 Dividing Mound.

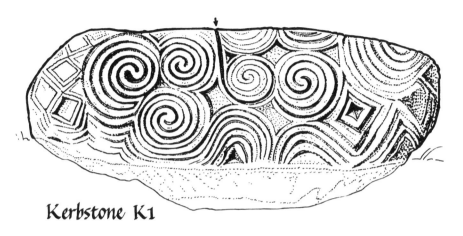

Kerbstone K1

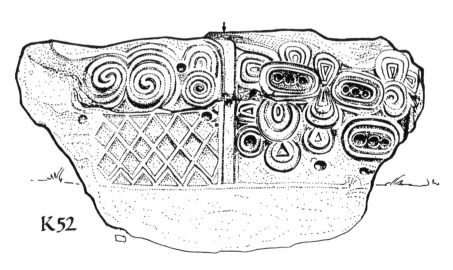

K52

A YEAR is marked by 2 solstices and the solstice divides into 2 equinoxes. Similarly, 1 lunar month is divided in 2 phases. Full moon and new moon are turning points in time, like the solstices. So the pattern of the sun and moon cycle is that of a whole circle, 1, divided by a line through the centre, 2, cutting the circle in two halves. These two primary points in the cycle, reflected in the alignment of the two kerbstones K1 and K52, "cut" the circle, providing the "gap" whereby the circle is connected to the centre by a direct line or path. This path is the passageway into the mound, along which the sun sends a beam every year and the moon every nineteen years.

[28]

This diameter between the two stones coincides with the passage between the central chamber and the entrance, and points towards the southwest winter solstice sunrise. The tomb aligns with the first beam of the solstice sun that passes precisely through the window-box above the entrance and fills the inner chamber with rosy light. On this morning after the longest night, the souls of the dead were believed to depart through the "gap of the year" when the sun, and indeed time itself, stands still. This ancient belief places death in the role of midwife to life through the celebration of Winter Solstice, which begins with the death of the sun on Mid-Winter's Eve.

[29]

AT the end of the longest night, the gateway opens between this timebound world and timelessness. Just as the tide of darkness turns, the earthbound spirit would have been touched by the ray of the newborn sun, as by the far-reaching finger of *Lugh Lamhfada*, "Luke Longhand", the Irish Sungod. The spirit departing in this way would have been believed to join the Feast of Age in the banquet hall of Boand, at which the aim of the tomb builders was to ensure the attendance of their dead. There, guests partake of the cauldron of eternal renewal. The solar alignment is marked by spirals carved on three stones, kerbstones K1 and K52, and in the inner chamber, stone C10.

FIG. 14 Path of Light through Entrance
Window at Midwinter.

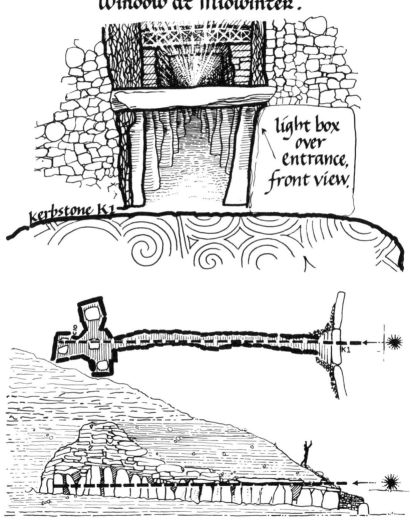

light box over entrance, front view.

kerbstone K1

K1

INSIDE the inmost chamber on the standing stone to the right of the broken basin, stone C10, there is a second triple spiral. Evidently we should compare this with the triple spiral on the entrance slab. They would both seem to have been placed there to be read, the outer one by the passing visitor, the inner one by one privy to the central mystery of the site: one guards the doorway; one overlooks the stone basin by which the dead may once have been laid. Perhaps this inner spiral was intended to pacify the spirit of the deceased, to guide it out of this world. Or per – haps it held a secret of a sort the living soul should know.

Fig. 15 Spirals from Inner Chamber
of Newgrange, Stone C10.

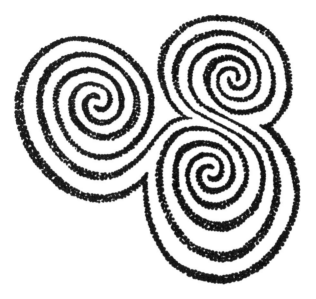

3 lines form 3 double spirals; 2 of
them an S-scroll, each centre connected
to the other by one path, and exiting
to either side by the other. The S-scroll
is enclosed by a line branching into
a third spiral to the left, to exit.

[33]

THIS spiral on stone C10 is a basic maze, called monocursal, mean-ing there is one pathway running throughout, with no dead ends. But there are three forks in the path, and two distinct circuits. There is one entrance that is also the exit. You enter and pass through the spiral on the left into the enclosure surrounding the S-scroll circuit. Here it is possible to skirt around the outside and return to the exit without having traversed the inner circuit. This short-cut would only partially cover the course. If we read this as a metaphor for a human life, such a route would miss the core experience, and leave the unwary traveller none the wiser.

FIG. 16 Construction of C 10.

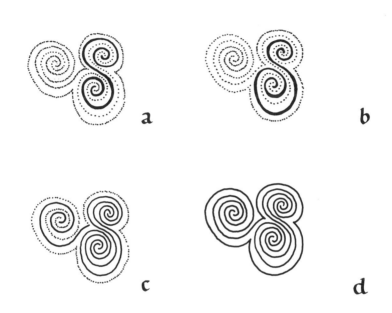

a

b

c

d

2 lines form a S-path, a , b. The form is
enclosed by an outline, c, from which
branches another spiral, open-centred so
that the path doubles back along itself
and out, forming a maze.

A CONVENTION of passing through a maze is always to turn in the same direction at every fork in the path. But by always turning right at each junction in this maze, RRR... , you would skirt around the inner circuit and exit without having completed the course. Likewise if you turn to the left each time, LLL... . However, if you alternate LRLR, or equally, RLRL, you wind up caught in the middle of the maze, swinging from one pole to the other of the S-scroll. The solution to the maze is either LLRLR or RRLLR. If my life depended on remembering the solution to this maze, I might think of it like footsteps; RRR or LLL, a hop; LRLR or RLRL, a walk; and LLRLR or RRLLR, a dance. The secret

of the maze would then read as; to
cross this maze neither stick to either
extreme, nor to an unvaryingly
regular pattern, but first establish a
pattern and, in the end, break out
of it, for the path of moderation
can be as much of a handicap as
that of the extreme: avoiding
extremes can be taken to extreme.
This principle of not sticking to
one way or another, nor alternat-
ing between both, is the solution
in terms of right- and left-hand
turns. But this is not the only
interpretion. We might equally
look at it another way: that we have
an outer path and an inner one.
The outer is an extension of the
spiral to the left, which provides
the means of entry and exit.

[37]

The inner circuit is distinctly con-
tained, comprising the two spirals
on the right. The spiral on the left
is **1**, those on the right are **2**, so that
as well as outer and inner, we have
odd and even, as well as left and
right. The completion of the maze
requires passing through in such a
way as to balance unity and duality,
odd and even, left and right. The
threefold pattern balances the
pairs of opposites within a greater
whole.

I point out these considera-
tions to illustrate the nature of a
symbol such as the triple spiral in
the form of a maze. There are many
ways to interpret the symbol, and
therein lies its value. Being non-
verbal, it yields endless meanings.

FIG. 17 The Geometric Plan of Newgrange.

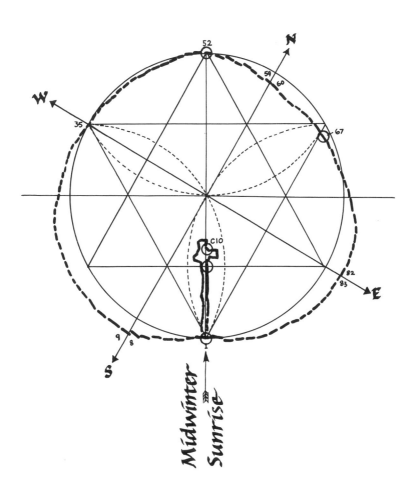

The plan of Newgrange contains the geometry of the six-pointed star in a circle. Here is its construction:

a Take the diameter of the mound and divide it to find the centre of the circle.

b Step the radius around the circle.

c Draw the star. The downward triangle touches kerbstones K1,K35,K67.

d Join the points of intersection of the triangles and project to fall between the stones K59 – K60. This line coincides with the North – South axis.

e Join opposite points of the triangles to make the horizontal arm of the cross, projected between K35–36 and K82–83. This line coincides with the East - West axis.

[40]

FIG. 18 **Geometry of Circle and Star in Plan of Newgrange.**

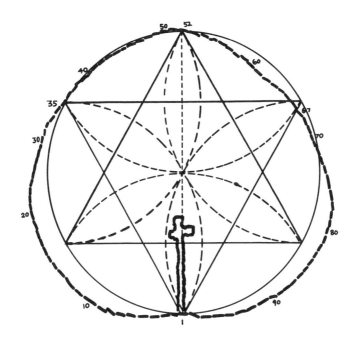

A S we can tell from the plan on the previous page, the align-ment of the kerbstones front and back of the mound, K1 and K52, gives us the diameter of a circle that cuts through the mound. Half of this diameter is the radius. The rad-ius, measured from K52, cuts the kerb at K67, which is richly decorat-ed to draw attention to the impor-tance of its relationship to the slabs at front and rear. It is carved with S-scroll hairspring spirals. The line from K67-K1 is the side of an equal-sided triangle joining K67, K1 and K35. The radius stepped off from K1 gives us the second triangle of the six-pointed star which touches kerbstone K52.

WE HAVE SEEN how spirals are carved on three of the major kerbstones, and how these relate to the hexagonal star geometry of the site. The clue to this pattern was discovered by seeing the relation-ship between the patterns of K1 and the two other kerbstones carved with spirals, K52 and K67. These three stones are sufficient to reveal the geometry of the circle underlying the odd shape of the kerb. Yet, even in the spiral construction of the entrance stone, the threefold geometry of the circle is implied in the construction of the triskele. Although at first glance the pattern looks quite freehand, it is almost impossible to reproduce without the geometry of circle and triangle.

Fig. 19 Spirals from Kerbstone at
Tomb entrance, Newgrange.

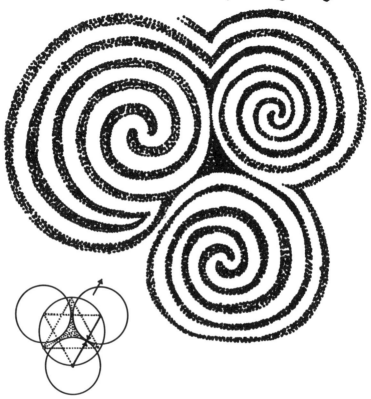

A S Claire O'Kelly has said of the entrance slab at Newgrange, " There is nothing accidental about the siting or the ornamentation of this fine slab." For instance, the mound is designed to exploit the winter solstice sunrise. There can be nothing accidental about such orientation. Neither can the decoration of the slabs be accidental. Several stones, such as the kerbstones at the entrance and at the rear, K1 and K52, and also K67, give clues to the underlying plan of the building. These were decorated with spirals after having been put in place. They were clearly intended to be "read" in order to reveal the plan and the dedication of the site.

[45]

WE can read the geometry of the circle as a symbol of the repeating cycle or length of time, a line that curves around on itself so that its beginning and its end coincide. At the outset of a new cycle, whether it be a day, a week, a month, year or life span, there is always a sense of going forward, waxing, growing, learning. But at mid-cycle, a shift of direction occurs ~ even if unnoticed to the traveller on the journey, for the path is unchanged. The second half brings a sense of returning, retreating, waning, wasting, forgetting, that leads to the end of the cycle : the end of a day, a season, a life. This natural division of a cycle or circle applies to ourselves, as to all existence.

[46]

WE tend to sense our lives as a line
or path between birth and death,
beginning and end. But while this
may be so, the nature of cycles follows
the pattern of a wheel, in which all
that is born rises and falls in its turn.
As the wheel leaves a track in the earth,
time leaves a track in our minds.
This track of memory has a beginning
and an end. But to the wheel that
makes a track, the beginning and
the end are a single point turning
round a hub, just as the passing
ages of the world are like all the
sunrises that ever were, only
"one eternal daybreak rolling
round the earth". Sometimes we
sense the unity of the wheel, but
more often we see only the
beginnings and endings.

[47]

Maybe this is so because, like the mound of Boand, our brains are divided. One side leads us to think life is a trail and to dread its approaching end. The other side engages wholly in the present moment, as when we are "concentrating", or having fun. If a wheel could feel, it would gather up impressions as we do, focused just where it touches the ground. It would feel time passing and the world rolling continually past it, sense everything as ever changing except itself. But the ground is not changing, it is the wheel that turns. The feeling wheel, then, might well fear to stop, to come to rest; yet at the centre of its axis, the hub is always still, as is the fixed compass point of the turning circle.

[48]

We cannot explore the symbol of the
circle very far without encountering
the symbol of the cross. Hub and rim
of the wheel may be symbolized by a
dot-in-circle, a whole cycle, a
totality of 1. A straight line cut-
ting through this circle may be taken
to symbolize division of the whole,
a splitting in 2, as corresponding to
the solstice points in the year. A line
across the first would divide each
half, corresponding to the equinoxes,
and giving us the cross-in-wheel.
At Newgrange, the circle implied
by the ring of kerbstones is divid-
ed diametrically by stones K1 and
K52: the passage to the central
chamber lies along the diameter of
the mound; further, the passage
is cross shaped or cruciform.

[49]

Fig. 20 Geometry of the Square and
 circle in the plan of Newgrange.

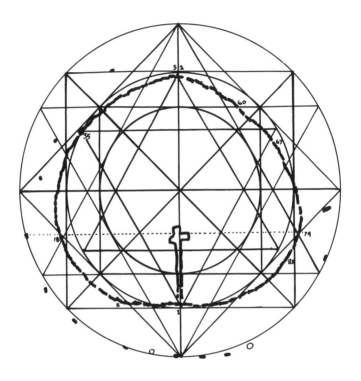

As well as the four seasons of the year,
the cross-in-wheel describes the pat-
tern of the phases of the moon. The
moon cycle, then, links with the
sun cycle by the number 4, but also
the number 13, as there are 13 moons
in the year. The mound of Newgrange
is divided by the 52nd kerbstone from
the entrance, the number of weeks in
the year, or quarter moons: there are
13 moons in a year, and $4 \times 13 = 52$.
The number of stones in the clockwise
semicircle is that of the number of moon
phases between winter solstices. So
the natural three- and four-part
geometry of the circle is reflected
in the structure of lunar and solar
cycles, and this in turn is mirrored
in the layout of Newgrange.

[51]

HE quartered circle also refers to the four points of the compass. The mound is orientated on the winter sun, not the compass. Yet, the NS axis falls between K 60 – K 8 (= 52 again). This line cuts the outer ring of marker stones, and forms a great cross and circle. The ends of this large cross form the corners of a square, enclosing the star of the inner circle, and concentrically aligned with it. The west side of the square aligns with the kerb-triangle at K 35, which with K 82 gives the EW axis. This completes the cross of the four winds, North, South, East and West. So here we find compass and calendar wheel combined in the union of the triangle and square.

[52]

THE numbers of the square and the triangle, 4 and 3, recur throughout Newgrange. The inner passage is lined with 43 standing stones, 22 on the left and 21 on the right. These numbers reflect the decoration on the entrance stone in their pairing of odd and even, threefold and fourfold, and 2 and 1 make 3; 2 and 2 make 4. Further, 27 (3 cubed) slabs in the passage are decorated. In the chamber, there are 21 more decorated stones (3 x 4 + 3; 2 + 1 = 3). In all there are 48 decorated stones inside the tomb, 4 times 12, 3 times 16 (12 is 4 times 3; 16 is 4 times 4). It seems that 3 and 4, the number of the triangle and the square, here take pride of place along with the symbol of the spiral.

[53]

W E now leave prehistoric spirals having examined them just enough to see that they were developing for thousands of years before the Celts, and that they can be explored as symbols full of meaning. Let us turn to the Celtic period proper, a couple of thousand years later. The Bronze Age has come and gone, without adding much in the way of development to the art of spirals. Now the Iron Age has begun to transform Europe, and the Celts emerge as a distinctive civilization with their own brand of decoration. In the next chapter we will survey the style of the Early Celtic period, in particular the La Tène style that was to emerge as the basis of Celtic spirals.

CHAPTER III
EARLY CELTIC, 500~350 BC

CELTIC SPIRAL ART begins to develop in the later 5th century BC. Up to then the art of the Celts was often hard to tell from that of their neighbours. Celtic spirals, S~scroll swashes and whirligigs are rooted in the "strict style" of early La Tène. The early style developed virtuoso compass work, as in the figures that follow which may be reproduced by compasses with ruling nib.

FIG. 21 edge Pattern from St Jean –
Sur-Tourbe Disc, France, c.410 BC

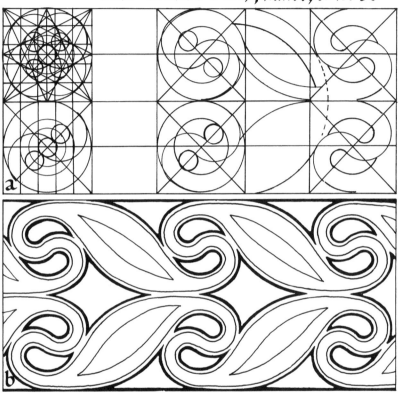

This border, b, is a series of S-scrolls
which can be laid out entirely with
compasses, as at a.

FIG. 22 Mask from Auvers-Sur-Oise
 Disc, France, c. 375 BC.

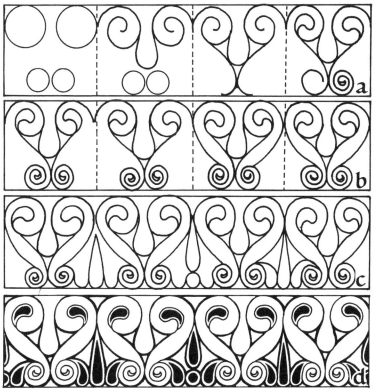

Swashbuckling opposed S-scrolls and
lotus buds frame a long, drop-like
nose, and curl into a forked beard.

FIG. 23 Mask from St Pol-de-Léon Pot,
Finistère, Brittany, c. 350 BC.

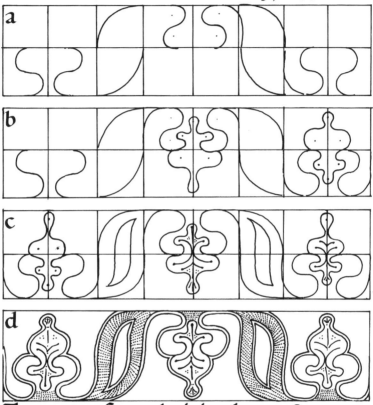

The centre form, b, joins by an S-
curve to an S-scroll on either side,
forming a mask-like pattern.

FIG. 24 Pelta-Palmette Border, Les
Commelles Jar, Marne, c. 350 BC.

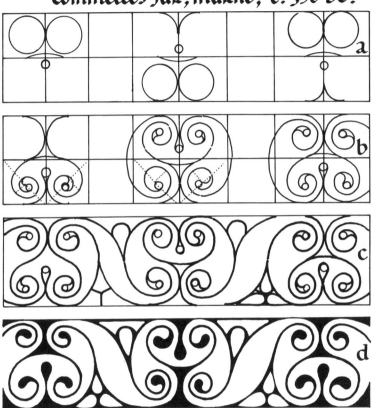

Diagonally opposed palmettes form N~
scrolls linked by a pelta that looks like
an elusive "Cheshire Cat" mask.

FIG. 25 Two Patterns from the
 Reinheim Flagon, c. 350 BC.

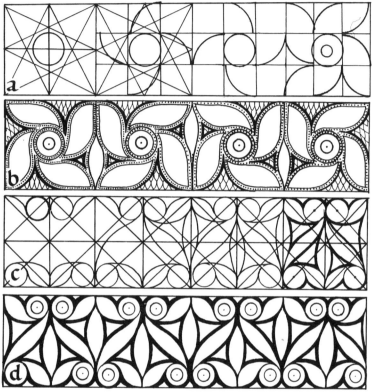

a,b reads as alternating lotuses,
or as four-armed windmills; c,d also
has lotus flowers linked diagonally.

IN the previous pages, we see a development: opposed S-scrolls, *fig.*21, to overall leaf-shaped lobes, *fig.*25. In *fig.*22, we see the lyre and lotus. The lyre is two opposed S-scrolls. The Greek lyre pattern typically encloses a fan-shaped palmette filler, here reduced to a single pendant. Between the upside-down lyres of *fig.*22 we find the lotus, a widespread motif which originated in Ancient Egypt. Here it is shaded to indicate the pink coral inlay of the original, reduced to three petals. *Fig.*23 is an opened lyre, the palmette veined as on a leaf. *Fig.*25 has the lotus, open or closed, or, equally, opposed wind-mills, *a*; and alternating with zig-zag S-scrolls, *b*.

FIG. 26 Waldalgesheim Leaf Motif.

WE HAVE SEEN ELEMENTS of the Classical lyre-and-palmette and the lotus motifs reduced to modules of early Celtic pattern. The Celts refashioned these elements to create a distinct formal language all their own. In this pattern from Waldalgesheim, *figs 26-29*, which ushers in the middle period of Celtic pattern, we see how the unit of the pattern has been reduced to a simple unit. The first example of this is based on a single compass-drawn petal, *figs 26, 27*.

Fig. 27 Construction of Leaf.

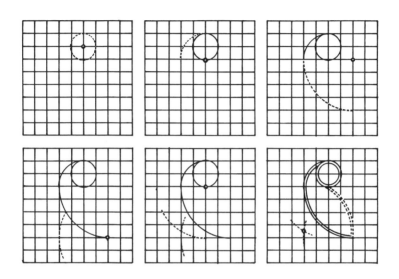

The single petal is rotated, fig. 28a, and mirrored to form a row of units that bear a nagging resemblance to a cartoon rabbit's face, fig. 28b. This row in turn is repeated in reflection to provide an overall pattern, fig. 29.

FIG. 28 Waldalgesheim Rabbit's
Head Pattern.

a Compass construction of motif.
b Mirrored on vertical axis forms
the "rabbit's head".

FIG. 29 Waldalgesheim Rabbit's
 Head Pattern, continued.

The rabbit's head becomes a full-length
figure when mirrored on the horizontal
axis. Look at the left-side column: the
upside-down, bottom unit may be read as
a body, with two arms and two legs.

[65]

fig. 30 Numeral Seven motif, Waldalgesheim, construction.

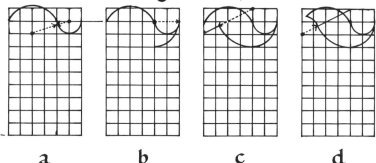

a b c d

a, 2 curves: semi-circle radius 1; arc, radius equal to diagonal of 3 adjacent squares.

b, third curve: a quarter circle, radius 2, dotted.

c, fourth curve: radius 3, drawn to cut the (dotted) diagonal of a rectangle 4 across, 2 down. From this cut on the diagonal complete curve five to the corner; d.

fig. 30 **Continued.**

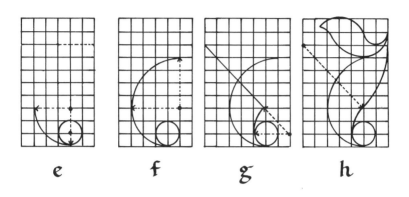

e f g h

e, radius 3 ;

f, radius 4 ;

g, radius 3 , cut diagonal of 7 square;

h, remainder of diagonal gives radius 5
of compound curve g , h. Complete motif
looks like a fat seven.

FIG. 31 Triangular Motif from Waldalgesheim Pattern.

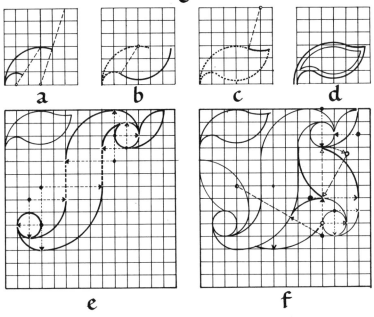

a b c d

e f

a-d, petal has different radii than fig. 30;

e, 4-curve S-scroll stretched between two circles, 2-curve lobe on top one;

f, third circle, 3-curve S-scroll to top, 2-curve lobe below.

FIG. 32 Double Triskele Motif
from Waldalgesheim.

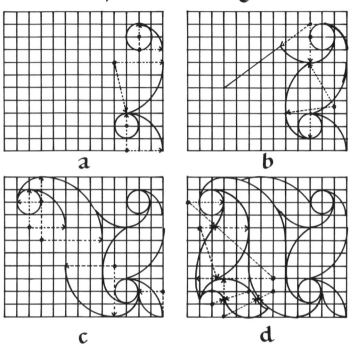

a

b

c

d

a–d The two previous motifs joined
together, in reverse and upside down. The
result may now be viewed as two triskeles,
the centre of each one a hollow triangle.

FIG. 33 four Units of the Pattern
from Waldalgesheim.

The Waldalgesheim pattern uses
this variation in the same pattern, the
difference becoming apparent in the
centre part, which incorporates part
of the rabbit's-head motif, *fig. 24.*

FIG. 34 Variation of Same.

The upper right quarter corresponds to the previous figure. The same construction has been followed for the other three quarters, reversed and reflected as required.

[71]

WITH the Waldalgesheim pattern we come to the end of the strict style of Early La Tène Celtic art, fifth to fourth century BC, and enter the middle style, that of the expansion of Celtic culture. This has been called Waldalgesheim style, for here we see the beginning of a language of ornament based on the elements of the lotus petal, and the S-scroll of the lyre motif, but abstracted and alchemized into a new form of decorative art, as in *figs* 26-34. This has also been called the Vegetal style, as the patterns sometimes look like plant tendrils. We shall examine this development in the chapter that follows.

CHAPTER IV
MIDDLE CELTIC, 350 BC ~ 100 AD

IN THIS PERIOD OF CELTIC expansion, Early La Tène grew through a tendrilly vegetal phase into Middle La Tène style, characterized as "Cheshire Cat Style", to account for the elusive faces that grin at us now and disappear again. It has also been called "Disney Style" because of these patterns' cartoon-like appeal. You will see why on the pages that follow.

FIG. 35 Manching Scabbard Pattern, Germany, c. 350 BC.

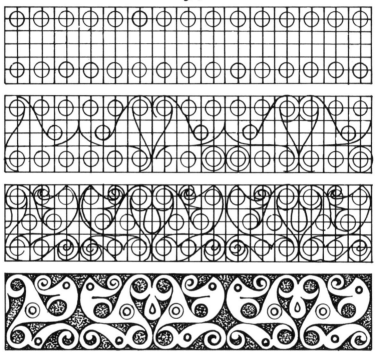

a-d This pattern of animal-headed triskeles paired in opposition has Celtic palmettes forming a face between each pair.

Fig. 36 Commaccio Flagon Mount,
 Italy, c. 325 BC.

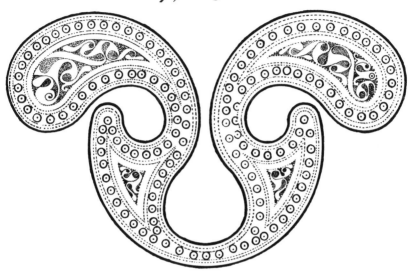

Each half of the flagon mount is a drop
shape with a curved triangle tail.
Together they form a mask, with comma-
shaped eye spaces and a central bulb-
shaped nose space.

[75]

FIG. 37 Commaccio Flagon Mount, Continuous Curves on Grid.

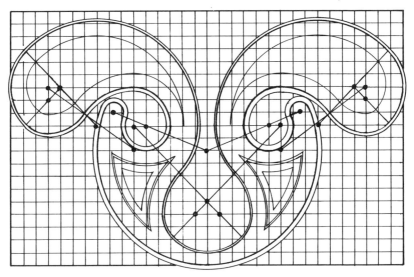

The dots are centres for the compasses by which the pattern may be entirely built on the grid as shown. I recommend you try this out yourself. It is fun to do.

FIG. 38 Commaccio Flagon Mount,
 Drop Treatment.

When you have finished the layout with
the compasses for fig. 37, here is how
to decorate it. The pattern is a series of
stippled drops centred on a triskele.
From the top of the triskele an S-scroll
leads into a head on the right, with
a circled eye. The whole figure is a
dragon, I think.

Opposite, fig. 39, the method for compass-drawing continuous curves:

a The 4-unit radius is stepped down from the centre of the topmost curve to that of the small arc. These two centres are at opposite corners of a single cell on the grid. It helps to pencil in the two diagonals as shown here, and mark the centres with dots.

b The fourth and fifth arcs also share a common line, the diagonal of a box five spaces across and seven down which may be pencilled first to ensure continuity. The fifth radius is 5 units long.

FIG. 39 Commaccio Flagon Mount,
Step-by-step Construction.

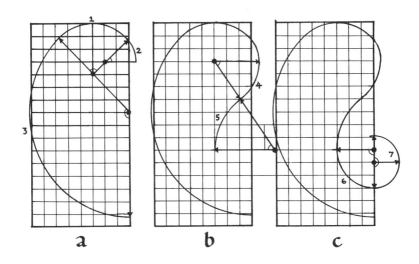

a b c

c The sixth is stepped down to 3 units,
and then stepped down to 2 to complete
the seventh curve, a semicircle.

fig. 40 commaccio flagon mount, construction continued.

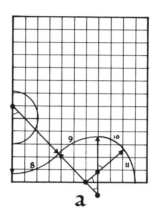

a

a Draw diagonals as shown. The eighth curve shares the centre already used for the sixth, and continues from the end of the third curve. The ninth curve is centred off the lower edge and goes to the vertical position. Step down the radius 2 units for the tenth curve. Open to the dot on the bottom edge for the eleventh curve.

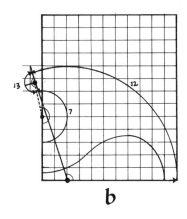

b

b The twelfth springs from the bottom
edge, centred 9 units from the lower right
corner, to cut the diagonal of a box six up
and two across. The thirteenth curve joins
the twelfth to the seventh. This completes
half of fig. 32. The other half is the same
in mirror reversal.

In fig. 41, a-e, we see the freehand construction of the stippled triangular cheek filler of the mask.

The pattern in the triangle may be read as an undulating form reserved against a stippled background. But to draw the pattern, you need to be able to see the background shapes. These turn out to be triangles with curved sides, with drop shapes or commas attached to their apexes, which are arranged so as to create the characteristic shapes of this, the Vegetal or Waldalgesheim style. The form of the path is based on the familiar S-scroll, with a swelling on one side that changes to a triangular form, tending towards a triskele.

FIG. 41 Commaccio Flagon Mount, Triangle Treatment.

a

b

c

d

e

[83]

FIG. 42 Umbrian Helmet, Border Pattern, Italy, c. 325 BC.

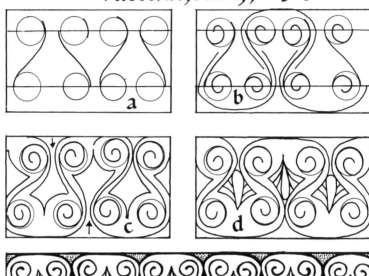

a Opposed S-curves and circles.
b Curves of the base of the lyre.
c Interior of lyre.
d Palmette filler.
e Complete pattern.

FIG. 43 Monte Bibele Helmet, Border, Italy, c. 325 BC.

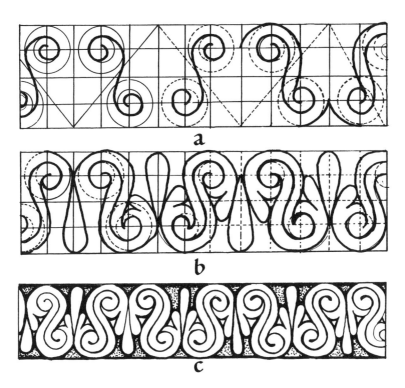

a

b

c

Here the lyres interlock, and the palmette is halfway to the three-leafed Celtic form.

FIG. 44 Canosa Helmet, Border,
 Variant One, Italy, c. 325 BC.

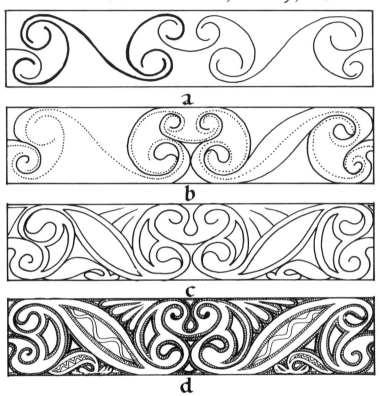

a

b

c

d

This design, related to the Les Commelles
jar, from the Marne, fig. 24, shows how
far south the Celtic style spread.

FIG. 45 Canosa Helmet, Border,
 Variant Two.

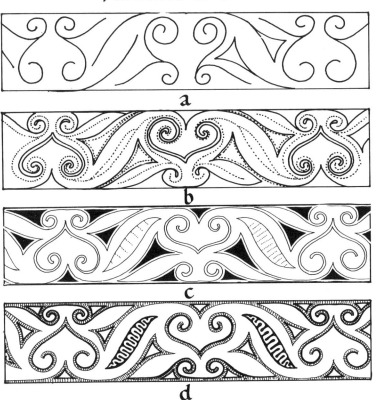

a

b

c

d

This pattern derives from that of *fig. 32*,
from Waldalgesheim. The helmet is of
the Celtic style of Alpine Italy.

FIG. 46 Filottrano Scabbard Pattern, Italy, c. 325 BC.

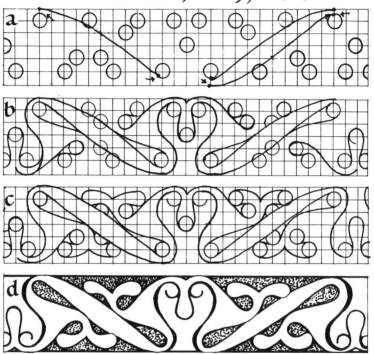

Triskeles paired in opposition with palmette reduced to a "Cheshire Cat" face in between, two closed eyes and a big nose.

FIG. 47 Amphreville Helmet,
 Triskeles, France, c. 325 BC.

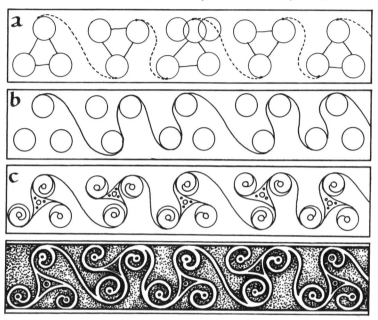

Running triskeles alternately
pointing up and down are linked from
top to bottom with S-scrolls in this
classic Gallic pattern.

FIG. 48 Amphreville Helmet, "Running Dog" Pattern.

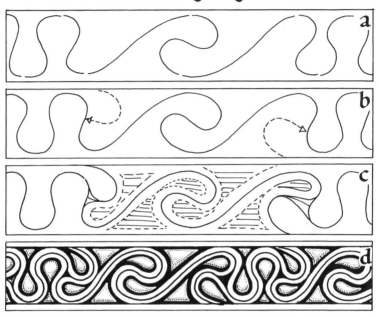

Another admirable design from the same Celtic helmet: pure double spirals spaced between pairs of triskeles linked by S-curves.

Fig. 49 Waldenbuch Pillar, Dog
Motif, Germany, c. 300 BC.

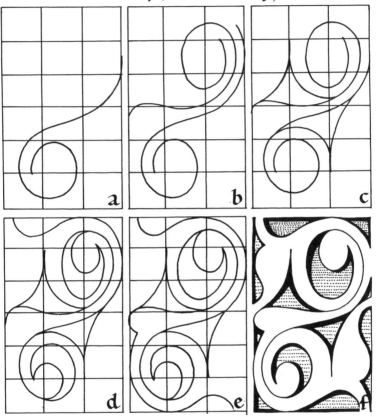

This S-scroll has laughing dog heads
like those of *fig.* 35.

FIG. 50 Waldenbuch Pillar, Duck Motif.

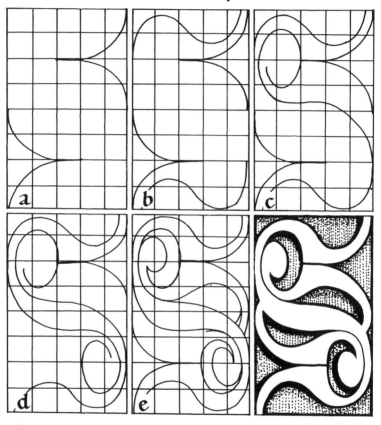

The S-scroll reads reversibly as a long-necked water bird.

FIG. 51 Waldenbuch Duck Motif, Horizontal Repeat.

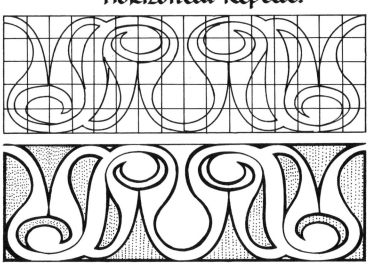

The Waldenbuch motifs are each
reduced to the bare bones, and
expressed with elegant economy. They
imply more with less . The duck in
this example is a module of a repeat
pattern that yields an eloquent
"Cheshire Cat" face of its own.

FIG. 52 Waldenbuch Dog Motif,
 Horizontal Repeat.

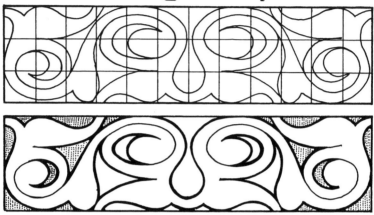

Similarly, two laughing dogs placed
tail to tail produce a face, with
similar eyes and nose, this one with
a moustache. The Waldenbuch artist
offered these motifs to discerning
viewers versed in the forms of
Celtic ornament.

[94]

FIG. 53 Waldenbuch Duck Motif,
 Vertical Repeat.

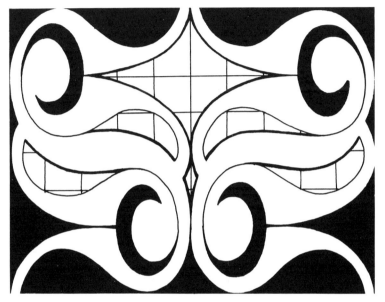

The duck is reflected , and irre-
sistibly suggests a mask , with
widely spaced eyes and flaring
nostrils. It looks amphibious to me,
like something the duck might eat,
or might be eaten by.

[95]

FIG. 54 Waldenbuch Dog, Vertical
 Repeat, Variant One.

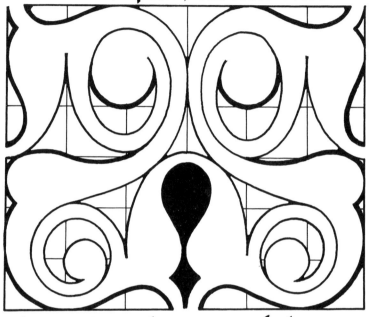

The laughing dog repeated, however,
produces a face with a very differ-
ent quality : goofy is the first
word that comes to my mind. I have
coloured in the part that to me
suggests a nose and mouth.

Fig. 55 Waldenbuch Dog, Vertical
Repeat, Variant Two.

Because the laughing-dog motif is
subtly asymmetric, it can be turned
around to produce a different tile.
Another cartoon character, this one
a bulldog, surely.

To be able to switch between abstraction and figurative art as Celtic artists have done shows their command of abstract art as much as their playfulness. Françoise Henry suggested that this ambiguity reflects the magical conception of the world, whereby " a vegetal pattern twined into a combination of curves is saved from becoming a stiff spiral by being transformed into a half-animal motif. These animals and plants are not only unheard-of species, they are also subjected to a strange transformism ...This multiform and changing world where nothing is what it appears to be is but the plastic equivalent of that country of all wonders that haunts the minds of the Irish poets."

CHAPTER V
EARLY INSULAR, 300 BC~100 AD

URING THE THIRD century BC, Celtic art was imported to Britain and Ireland and there was soon adapted to a variety of indigenous Insular styles, both regional and common to both Isles. The lyre, with leaf – or fan-shaped filler, developed into running S-scrolls, combined with tendril and running–triskele patterns. These became the main elements of Ultimate La Tène from 100 AD on.

FIG. 56 Running Triskele, Liter
Scabbard, Hungary, c. 300 BC.

a-d Construction of running triskele
pattern.
This very popular design spread all
over the Celtic territories during
the expansion period, and appears
in the earliest Insular art.

FIG. 57 Running Triskele, Standlake, England, c. 300 BC.

a b

c d

This pattern is typical of the continental sword-style, such as its prototype from Hungary, fig. 56.

FIG. 58 Split Palmette, Cerrig-Y-
Drudion, Wales, c. 300 BC.

a b

c

This unfolded lyre with split-leaf
fillers is in the continental style
of *fig.* 44 , but the crosshatching is
typically Insular.

FIG. 59 Running Lyre, Wisbech Scabbard, England, c. 250 BC.

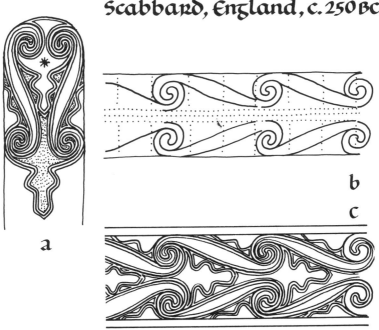

a

b

c

Here the lyres are stacked: the topmost centre shape*descended from that of *fig.19* is split along the outside edge.

FIG. 60 Running Tendril, Wetwang
 Slack, England, c. 300 BC.

a

b

This truly vegetal, tree-of-life
pattern - from which the running
triskele evolved - was also very
popular in early Insular art.

FIG. 61 Lisnacrogher Scabbard, #1, N. Ireland, c. 150 BC.

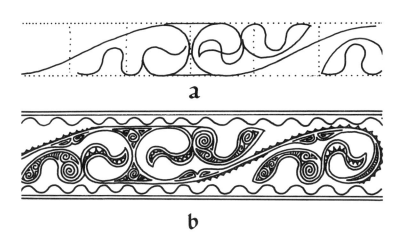

a

b

These stacked S-curves with laugh-ing-dog heads, hairspring spirals and scalloped lines are in the early Irish sword-style.

FIG. 62 Lisnacrogher Scabbard, #2,
 N. Ireland, c. 150 BC.

a

b

The opposed S-curves of this design
end in forms resembling birdheads
(line, foreground) or commas
(path, background).

FIG. 63 Lisnacrogher Scabbard, #3,
N. Ireland, c. 150 BC.

a

b

This continuous running tendril has
lines produced to capture background
in single spiral paths, a perfect line-
path equivalence.

FIG. 64 BRENTFORD Knob Roundel, England, c. 100 BC.

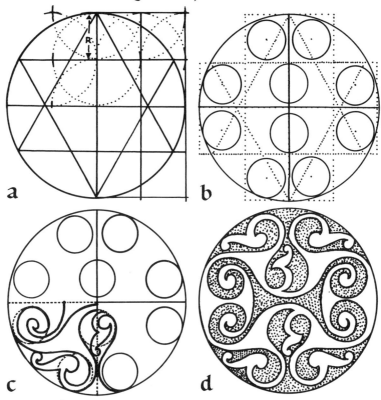

a

b

c

d

This famous pattern reads as two
lyre-and-peltas connected centrally,
and opposed triskeles with birdheads.

FIG. 65 Silchester Disc Brooch,
England, c. 25 BC.

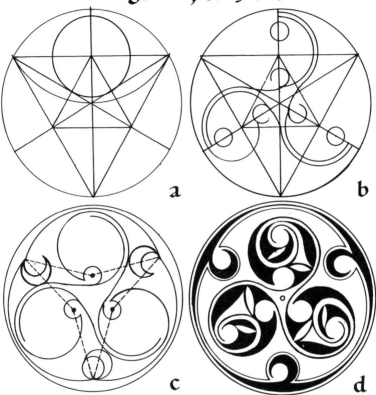

a b

c d

A triskele encloses commas and
trumpets, both standard elements
in Celtic art for centuries to come.

[109]

FIG. 66 Rodborough Casket strip, England, c. 25 BC.

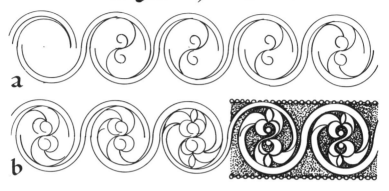

a

b

a, b Construction

After the late first century BC, Celtic spiral patterns grew increasingly rare in those parts of Britain under Roman rule, but the tradition survived along the fringes of the empire.

FIG. 67 Triskele, Tal-y-Llyn, Wales,
c. 25 AD.

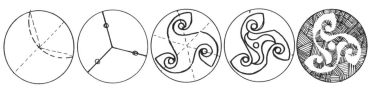

Here the background voids take on a
life of their own, typical of
British Celtic art of the time.

FIG. 68 Triskele, Lambay Island,
Ireland, c. 70 AD.

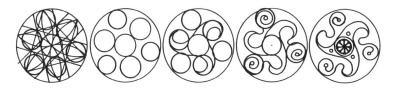

In Ireland there was a revival of
compass-work, as seen by the
underlying geometry. The central
rosette is a Romano-British motif.

[111]

FIG. 69 Triskele, Moel Hiraddug
Plaque, Wales, c. 50 AD.

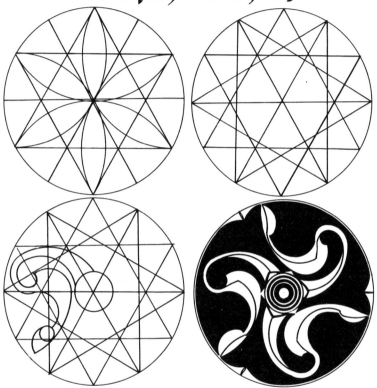

The Celtic influence is still intact
in this construction, from Roman
times.

CHAPTER VI

ULTIMATE LA CÊNE 100 – 650 AD

FROM the first century compasses were used to make spiral patterns, as part of Celtic craft training, and later as part of monastic training. Even when free-hand methods were used, they derived from "an incredibly clever play of compasses...", as Françoise Henry noted. The spirals may be copied freehand from the layouts given here.

FIG. 70 Single Spiral, Construction.

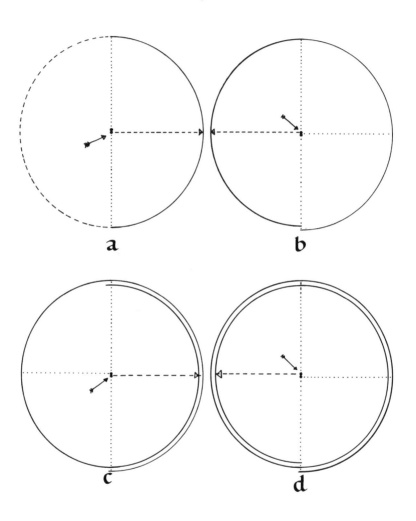

a b

c d

The simple spiral construction:

a Draw a right half circle.

b Step fixed compass point a little above the centre, arrowed, with the moving point continuing from the first curve, to complete one turn.

c Return fixed point to first centre, draw third semicircle from the bottom of the second.

d Complete turn of path as shown. Width of the path is twice the distance between the two centre points. Vary the tightness of the coils by spacing the centres closer or wider apart.

FIG. 71 Single and Double Spiral.

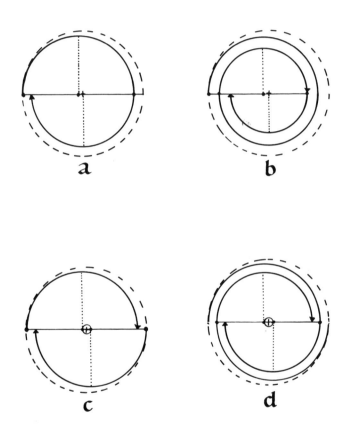

a

b

c

d

The double spiral is based on a diagonal, as is the single. They both use two centres. By stepping from one to the other, and reducing the radius, decreasing semicircles may be drawn continuously:

a,b This single spiral is a wider coil than the last, the centres wider spaced. The centres are set on a horizontal diagonal, which has the effect of turning the spiral through a quarter turn.

c,d Each spiral of the double spiral starts from one or other centre, and continues in the same way as the single spiral, stepping the fixed point from one centre to the other.

[117]

FIG. 72 Triple Spiral Construction.

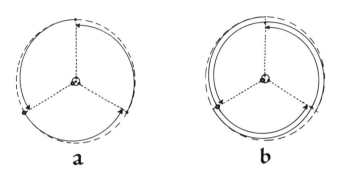

a b

a In the triple spiral, the circle is
divided into three. The centres for each
spiral are arranged on a central circle,
each one set on its own radius and
turned a third of a turn to the next
radius, shown here by the dotted line.
The setting off curves are drawn here
as arrows.

b After having drawn the three
initial curves, repeat the process
using the same centre points as before,
but with the moving point of the
compasses stepped down so that each
curve continues from the end of the
previous one.

In these examples, only a single
turn of the path is produced, the
minimum needed to separate the middle
of the spiral from the outside. Of
course the spiral may have more than
one turn, by simply repeating the
procedure for as many coils as you
like. In drawing these, I have used
compasses with a crab-claw ruling
pen nib attached.

FIG. 73 Comma Terminal Mask.

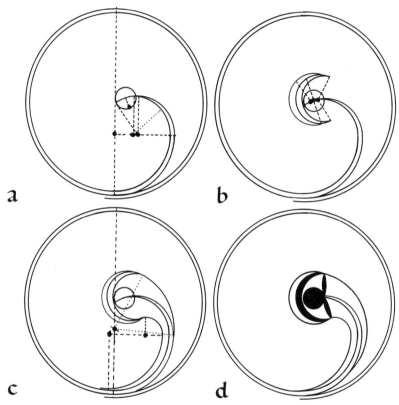

a

b

c

d

This single spiral construction from the Irish Petrie Crown, of c. 50 AD, looks like a clown face mask.

On the following two pages, we
explore the construction of the bird
head terminal, also taken from the
Petrie Crown. This is an exercise in
tight-coiled spiral construction,
the double spirals being drawn very
close together. The effect is to make
the most of the area in the middle of
the spiral, which is then decorated
by the bird head. The bird head
terminal in this Late La Tène work
was subsequently made a stock
feature of the Ultimate La Tène
style, and lasted through the first
half-millennium into the period of
illuminated manuscripts.

FIG. 74 Double Spiral Birdhead, Compass Construction.

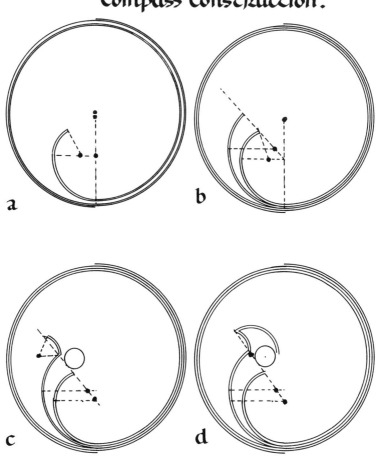

a

b

c

d

FIG. 75 Double Spiral Birdhead, continued.

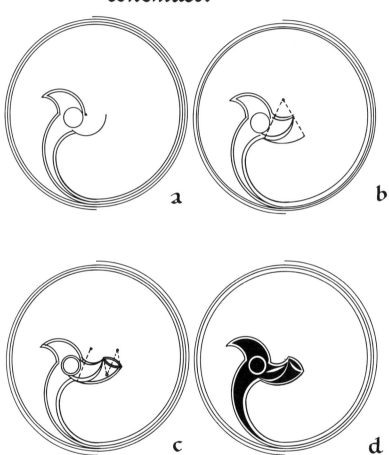

In the figure opposite are six
variations of the double spiral.

a The line is given two turns,
giving a path of one-and-a-half
turns on each spiral.

b The paths swell and end in
club-head terminals.

c The lines end in solid comma
terminals, leaving a serpentine S-
path between.

d The continuous line swells
through a half-turn to the centre.

e Here the continuous line passes
through a complete turn to centre,
diverging and converging.

f The line is continuous, while
the path stands out as two inter-
locking hooks.

FIG. 76 Double Spiral Variations.

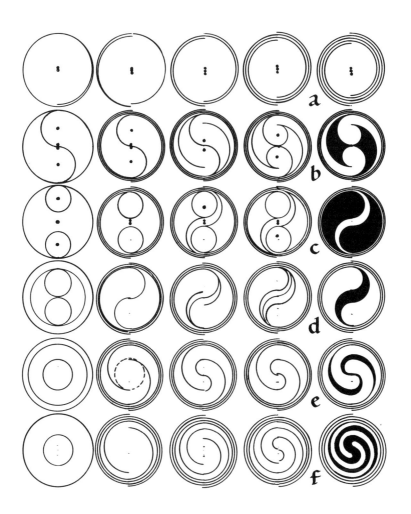

Opposite : a series of double spiral variations.

a The two paths end in single spirals with yin-yang comma terminals.

b A variation on the same, the Roman-British dotted-club terminal, c. 450.

c This design is from a Pictish pin, c. 500.

d The divergent trumpet terminal style of Ultimate La Tène metalwork, c. 550.

e Dotted-club or bird head, from a hanging bowl, c.600.

f For comparison, the clown mask of fig. 73 adapted to the double spiral.

FIG. 77 Double Spirals, Continued.

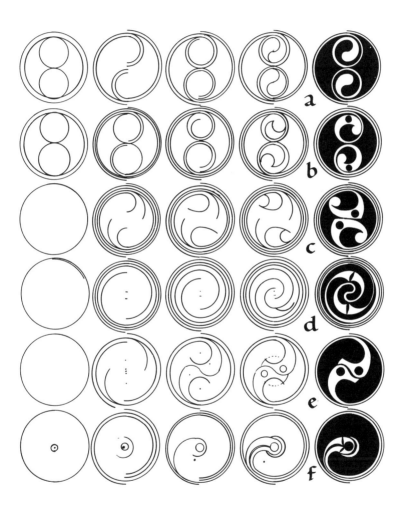

FIG. 78 Spiral Panel, Book of Durrow, Ireland, c. 650 AD.

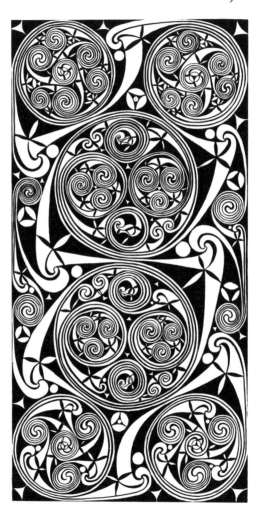

CHAPTER VII
The GOLDEN AGE, 650 ~ 850 AD

THE GOLDEN AGE of Celtic spiral pattern springs into full bloom with the art of painting books. The Book of Durrow heralds a new level of logically connected overall pattern but there is no good reason to suppose this great design was the invention of one virtuoso; more likely, it was the fruit of a growth going on for a generation before.

FIG. 79 Double Spiral Horsehead, Book of Durrow, c. 650 AD.

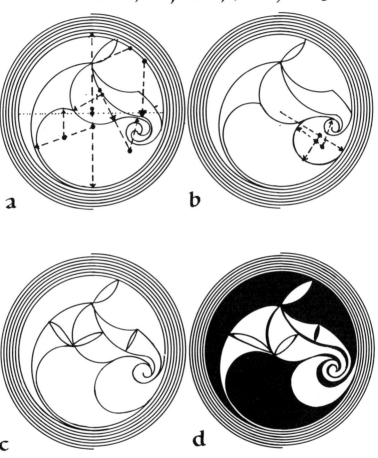

a b

c d

With the coming of books, Celtic
spirals from weaponry and warrior
gear were applied to peaceful ends,
resulting in an eruption of creativity
that elevated the ancient forms to
new heights. These classic designs
may be drawn by compasses, as was
the case with metalwork in earlier
times, or they may be drawn freehand
with a very fine brush and ink. For
the sake of clarity I have chosen here
to use compass drawing for most of
the examples given, and also to offer
some practical demonstration of the
craft methods of compass play and of
continuous curvature.

FIG. 80 Compass Division of Circle into Six Parts.

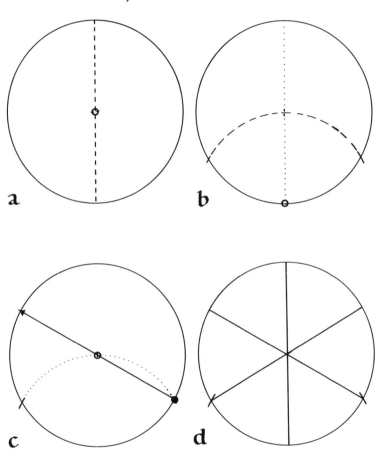

The best known way to divide a circle
into six is by stepping off the radius
around the circle. This gives three
diagonals of the hexagon – or diameters
of the circle – required for drawing a
triskele. Every second point may
then be joined to the centre to give
the three arms of the triskele.
However, I have also found the
following method to be useful, as
demonstrated in fig. 74.
a Draw the first diameter in pencil.
b From the bottom of this line,
cut the circle with its own radius.
c,d Draw a line from each end of
the arc through the centre to the other
side.

FIG. 81 Double Spiral Triskele Roundel, Construction.

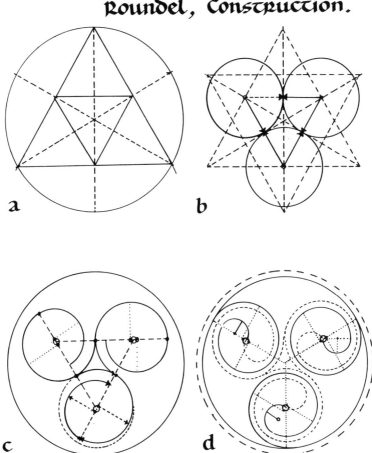

a

b

c

d

FIG. 82 The same, continued.

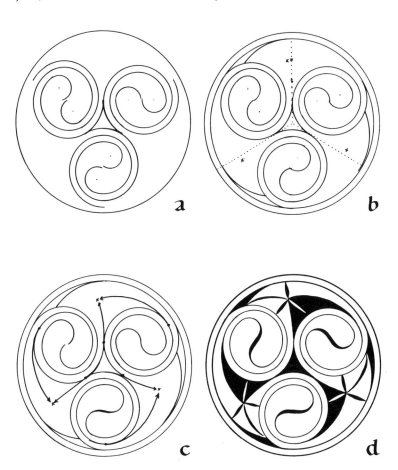

a

b

c

d

FIG. 83 Previous Figure Adapted to
a Double Spiral.

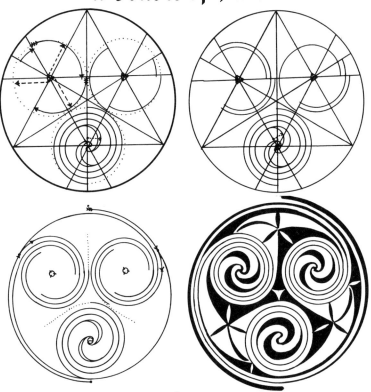

The two upper spirals, raised to triples,
break the roundel with two loose ends.
The roundel is now overall a double spiral.

FIG. 84 Triskele Roundels.

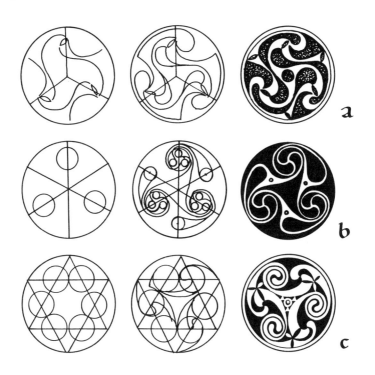

a Stoneyford Pick, c.550.
b Pictish pendant, c.600.
c Hanging bowl, Oliver's Battery, c.600.

FIG. 85 Triple Spiral Variations.

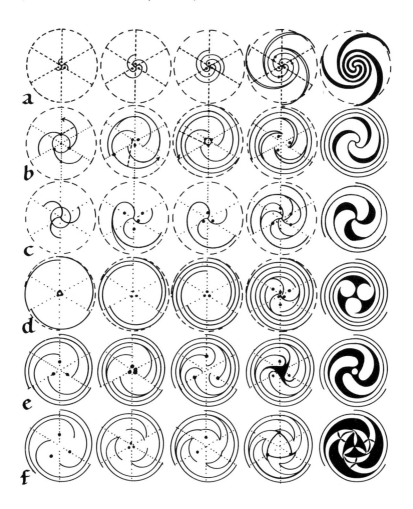

a
b
c
d
e
f

FIG. 86 More Triple Spirals.

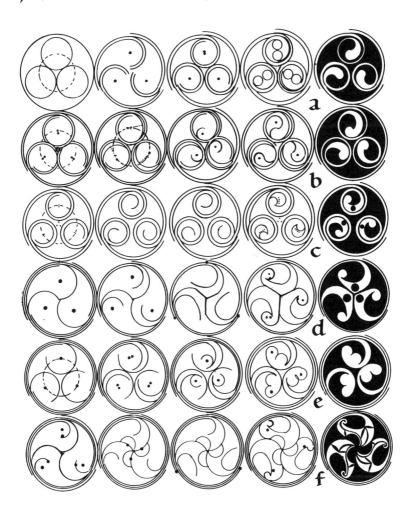

FIG. 87 Triskele Roundel set in Square, Construction.

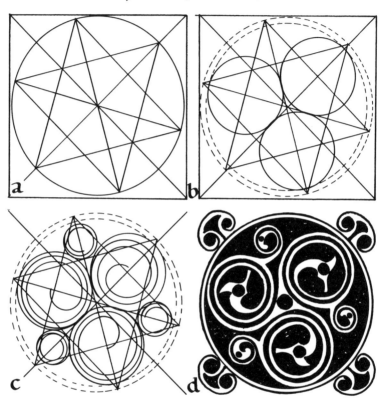

Crested bird head from Ireland, c.550.
Diagonals of hexagon and square align.

FIG. 88 Triskele Set in Twelvefold
Division of Circle.

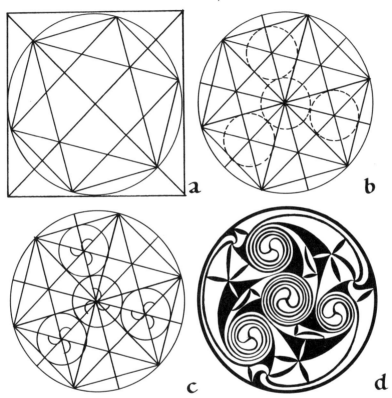

a

b

c

d

From the Hitchin hanging bowl, c. 650.

FIG. 89 Double Spiral Triskele.

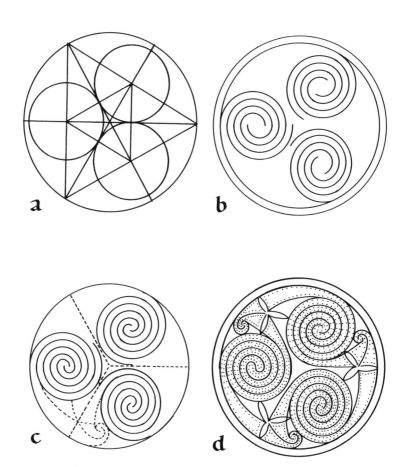

a

b

c

d

From the Gracey chalice, c. 700.

FIG. 90 Triskele, Chipcarved Style.

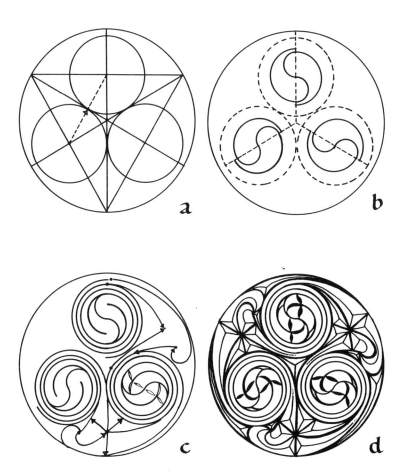

a b

c d

From the Londesborough brooch, c. 800.

FIG. 91　Tripartite Roundel,
　　　　　Donore, Ireland, c. 750 AD.

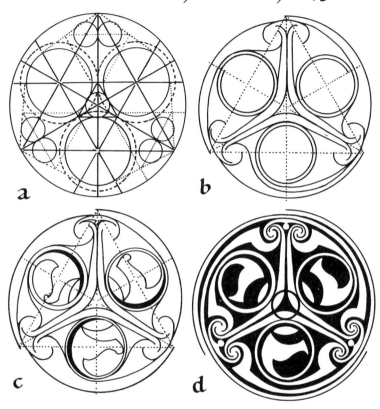

a

b

c

d

FIG. 92 Hooked Triskele Spiral,
Donore, Ireland, c. 750 AD.

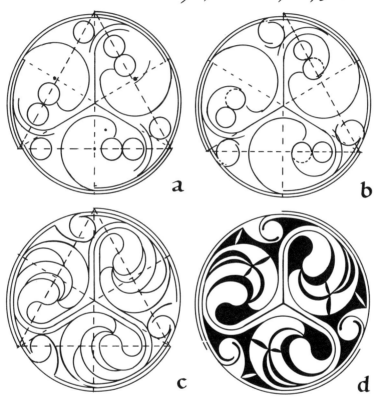

a

b

c

d

[145]

FIG. 93 Triple Spiral, Five-Spot Roundel Centre, Donore.

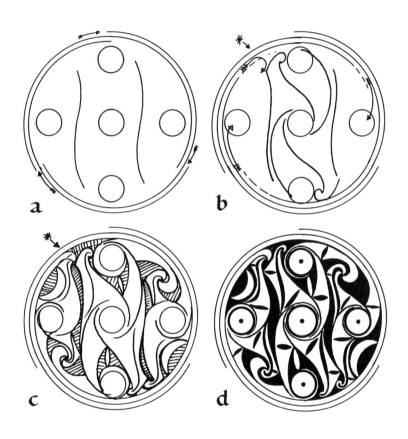

a

b

c

d

FIG. 94 Triple Spiral, Four-Spot
Roundel, Donore.

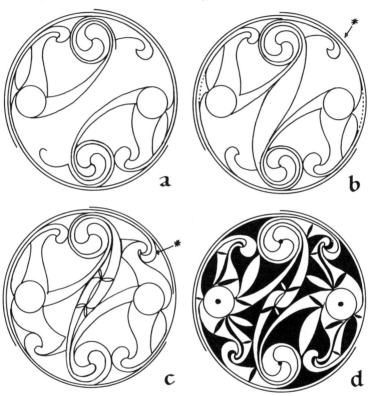

a

b

c

d

FIG. 95 Triskele, Single Spiral Snail Shells, Donore.

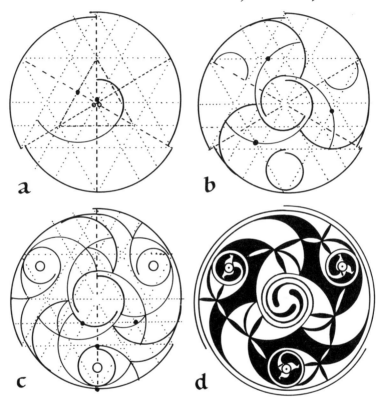

a

b

c

d

FIG. 96 Triskele, Double Spiral
Snail Shells, Donore.

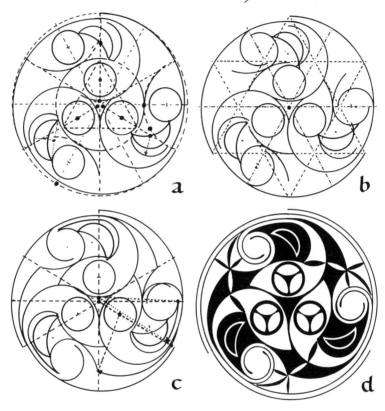

a

b

c

d

FIG. 97 Triskeles within Triskele,
Jatten, Norway, c. 750 AD.

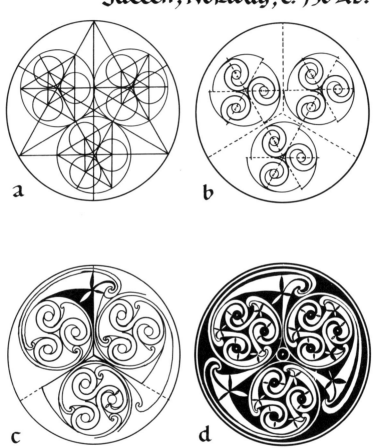

a

b

c

d

FIG. 98 Triskele Border, Donore.

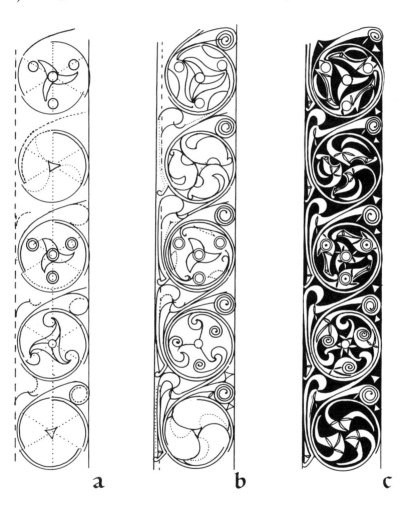

a b c

FIG. 99 Spirals, Lagore Buckle,
Ireland, c. 800 AD.

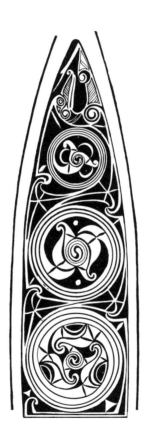

APPENDIX

GLOSSARY

C-scroll: path in form of simple curve, or letter "C".

Club terminal: spiral ending in a bean shape.

Comma: circular path ending.

Crested bird head: birdhead terminal based on triskele.

Dotted club: club terminal with an eye dot.

Lobe: a simple shape, like a leaf.

Lotus bud: a classical motif derived from Egypt, the lotus in profile.

Lyre: classical motif of opposed S-scrolls shaped like a lyre.

N-scroll: *a broken-backed S-scroll.*

Palmette: *a palm-like shape, often veined like a leaf.*

Pelta : *a C-scroll with coiled ends.*

Ram's head : *opposed single spirals, as a broken-backed C-scroll.*

Running S-scroll: *repeated S-scrolls, continuous line or path.*

Running triskele: *repeated triskeles, derived from tendrils motif.*

S-scroll : *two simple, opposed curves, or compound curve, like a letter "S".*

Split palmette: *an edge filler, shaped like a split leaf.*

Tendril : *a wavy line branching with alternating spirals.*

SIMPLE EXERCISES

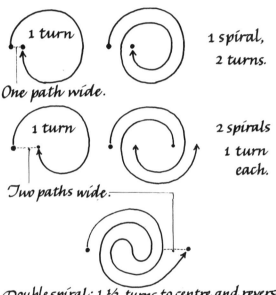

1 turn

1 spiral,
2 turns.

One path wide.

1 turn

2 spirals
1 turn
each.

Two paths wide.

Double spiral: 1 ½ turns to centre and reverse.

Two paths wide

Double spirals, continuous stroke.

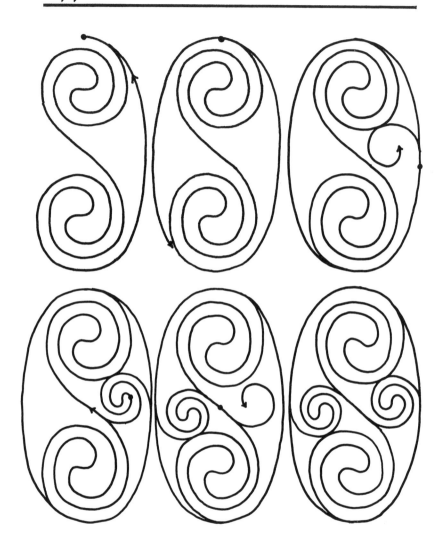

BIBLIO-
GRAPHY

Bain, G., Celtic Art, The Methods of
Construction, New York 1973

Brennan, M., The Boyne Valley Vision,
Portlaoise 1980

Crawford, H., Irish Carved Ornament,
Dublin 1980

Filip, J., Celtic Civilization,
Prague 1977

Gimbutas, M., *The Language of the Goddess*, San Francisco 1989
~ *The Goddesses and Gods of Old Europe*, Los Angeles 1982

Henry, F., *Irish Art in the Early Christian Period to AD 800*, London 1965
~ *Irish Art during the Viking Invasions (800–1020)*, London 1967
~ *Irish Art in the Romanesque Period (1020–1170)*, London 1970

Meehan, A., *Celtic Design Series:*
~ *A Beginner's Manual*, London 1991
~ *Knotwork*, London 1991
~ *Animal Patterns*, London 1992
~ *Illuminated Letters*, London 1992

Megaw, R. and V., *Celtic Art*, London 1989

O'Kelly, C., *Passage-grave Art in the Boyne Valley*, Cork 1978

Purce, J., *The Mystic Spiral*, London 1974

Romilly Allen, J., *Celtic Art in Pagan and Christian Times*, London 1902

Youngs, S., ed., *The Work of Angels*, London 1989

Appendix

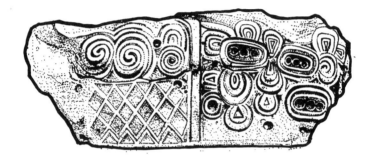

Kerbstone K52, at rear of Newgrange.